SOI BOOKS

Soi Books / Stickerbomb Ltd

This publication has been realised exclusively
with the purpose and intent of a critical
and satirical documentation and discussion.
The views expressed in this publication are
those of the respective contributors and
are not necessarily shared by the publisher
and its staff.

©2023 Tania Brun / Stickerbomb Ltd

Photography by Tania Brun (@tania_brun)
and Renato Rodriguez (@sucio_records).
Design & layout by Ryo Sanada and Suridh Hassan.

ISBN: 978-1-7397509-7-8
Printed in the U.K.

@bombstagram
www.stickerbombworld.com
www.soibooks.com

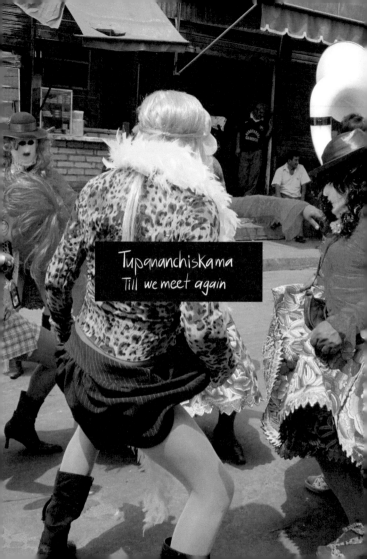

Tupananchiskama
Till we meet again

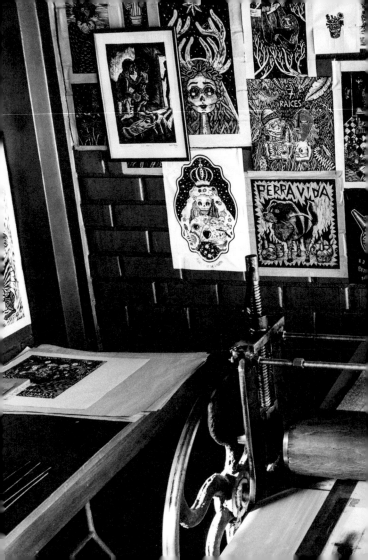

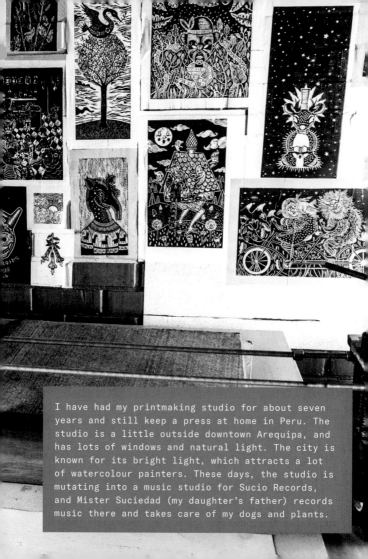

I have had my printmaking studio for about seven years and still keep a press at home in Peru. The studio is a little outside downtown Arequipa, and has lots of windows and natural light. The city is known for its bright light, which attracts a lot of watercolour painters. These days, the studio is mutating into a music studio for Sucio Records, and Mister Suciedad (my daughter's father) records music there and takes care of my dogs and plants.

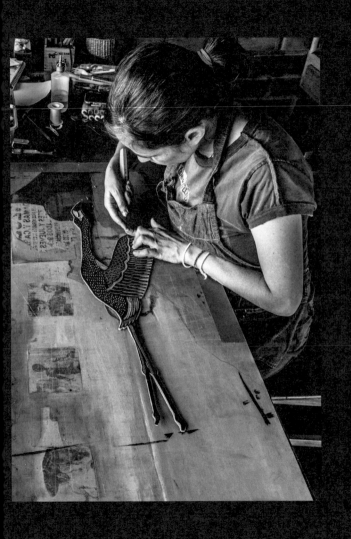

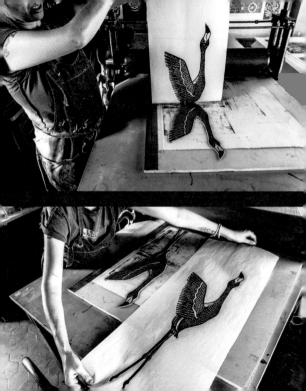

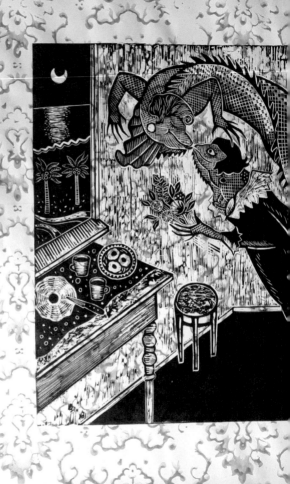

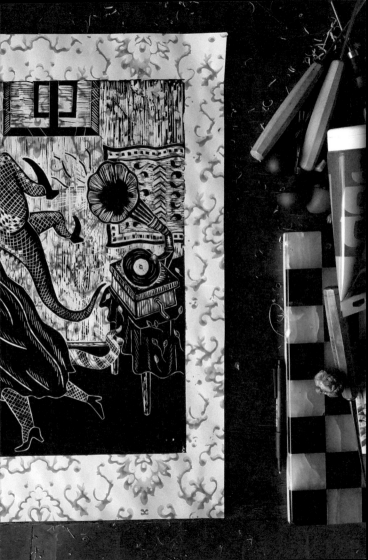

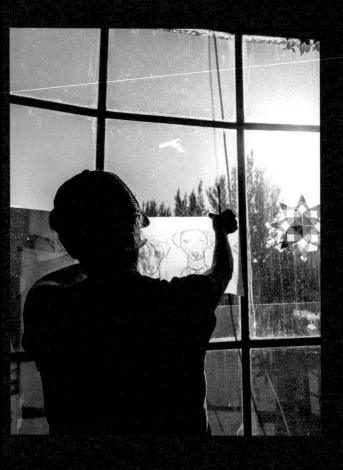

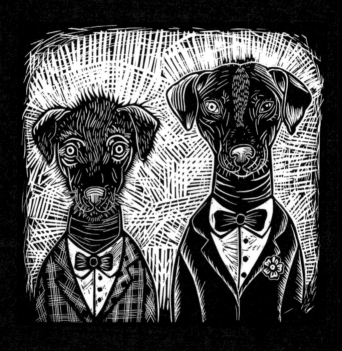

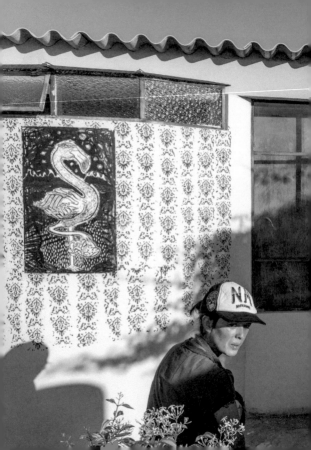

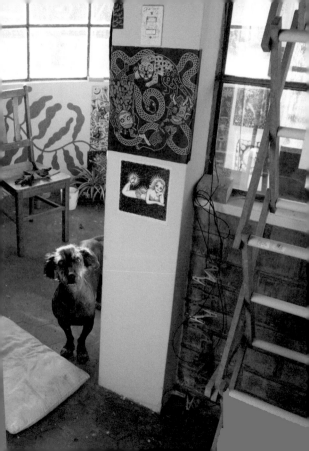

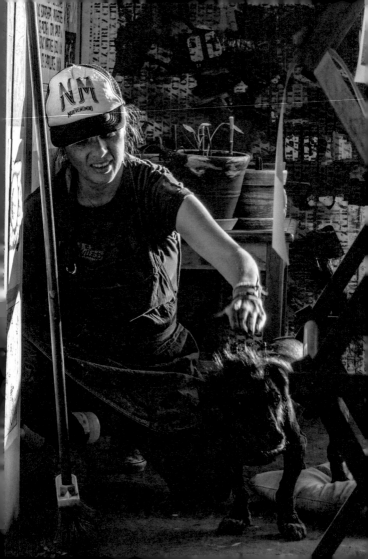

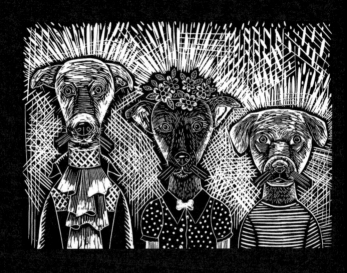

I have three dogs. They are a special kind of
hairless Peruvian dog, so I have to put sweaters on
them when it's cold. They are very loving dogs, but
nervous and a little crazy. Difficult to educate.
But maybe that's just me - I like that they are
rebellious, so I let them be.

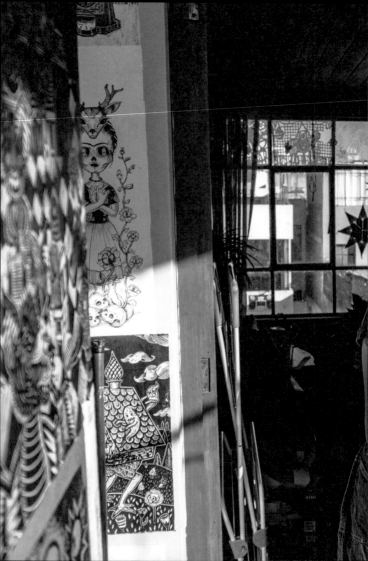

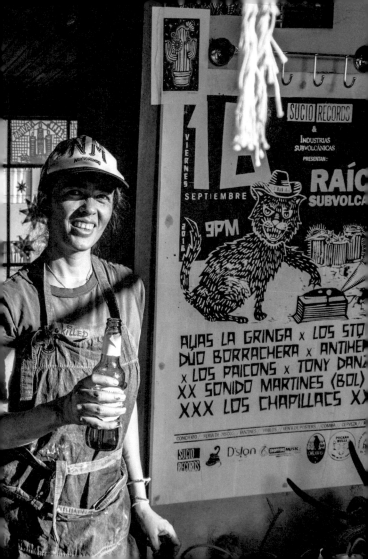

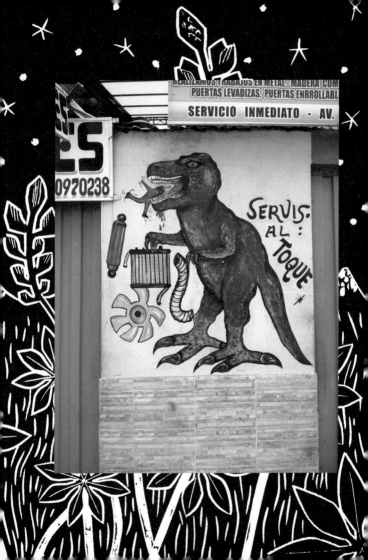

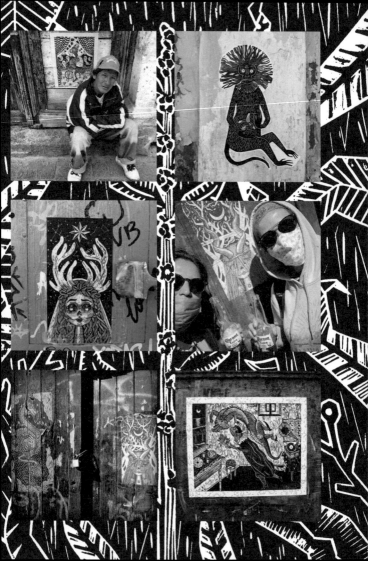

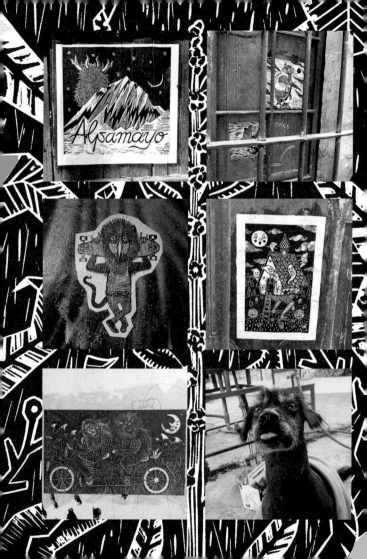

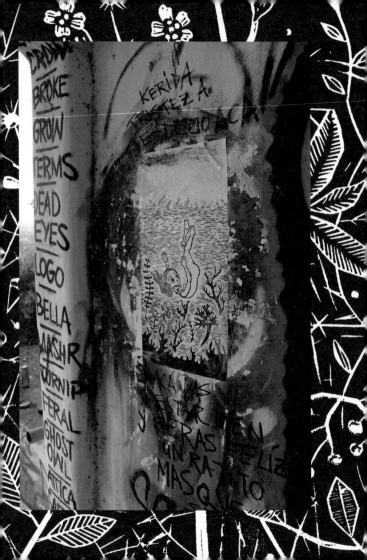

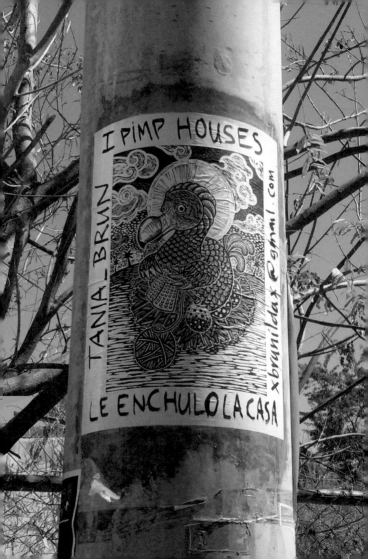

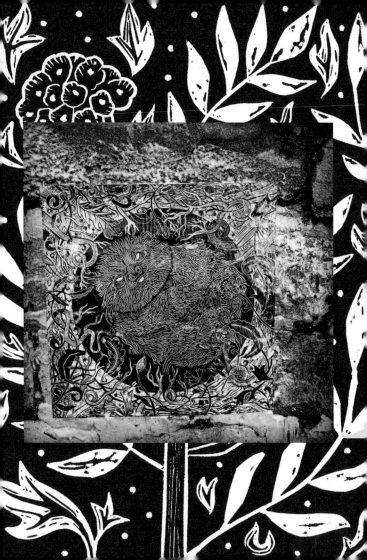

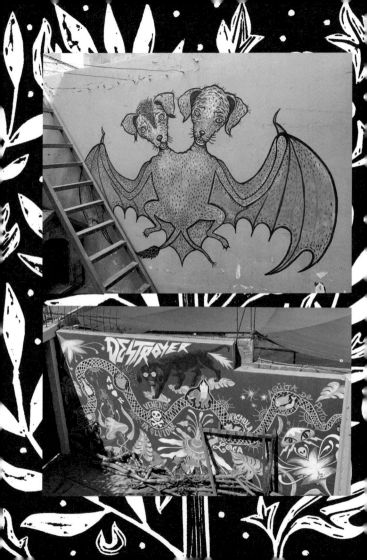

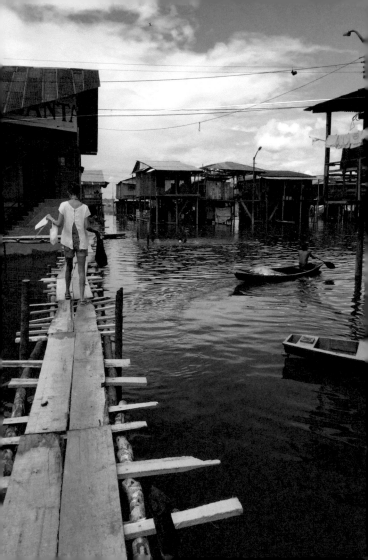

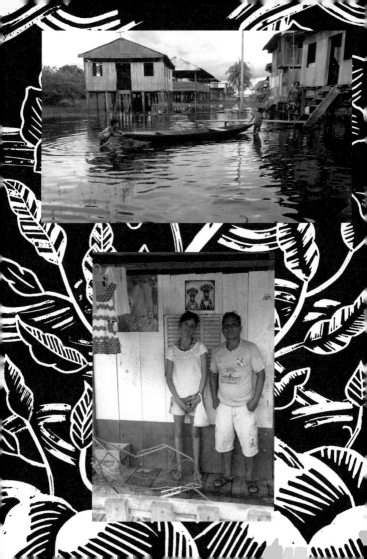

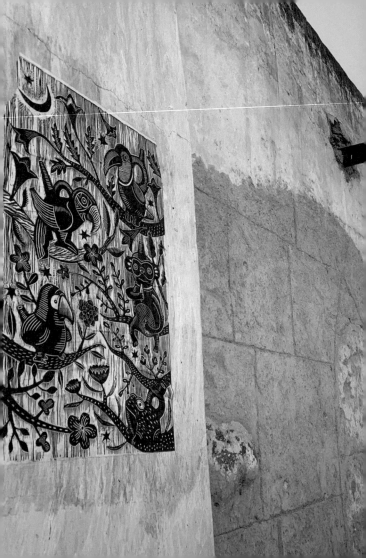

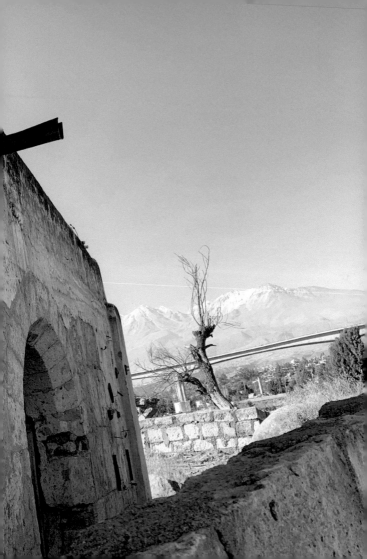

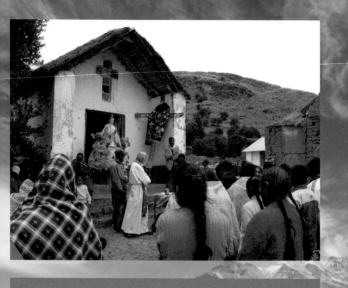

We used to live in a small town in Puno, where my father was a priest. He always taught us to appreciate the people of the Andes and not to take advantage of being half Swiss. He never spoke to us in his mother tongue. I think he wanted us to stay there.

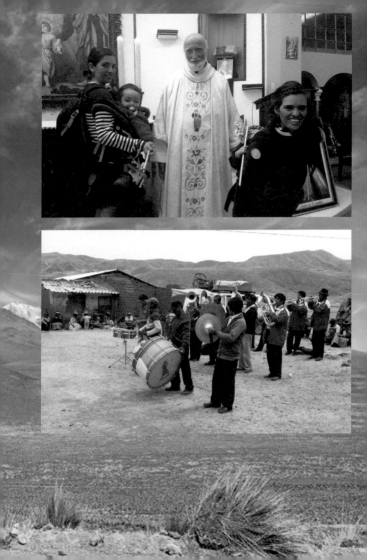

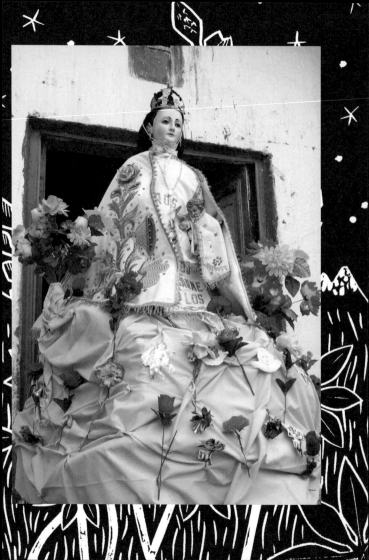

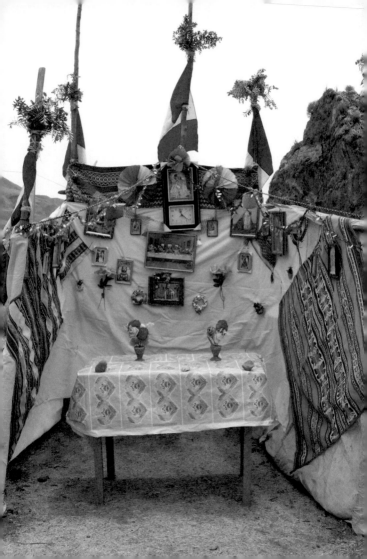

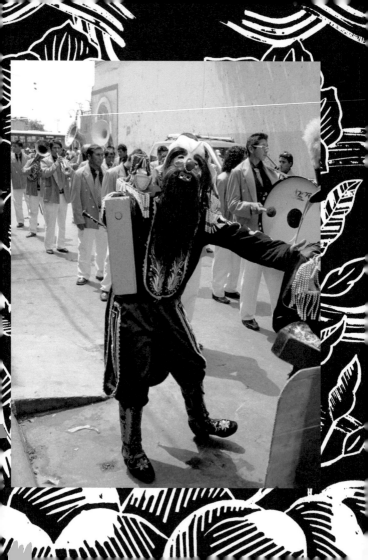

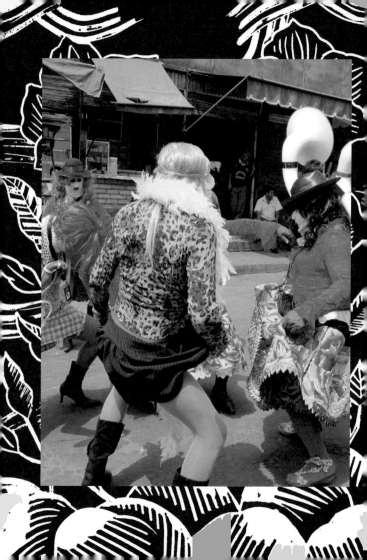

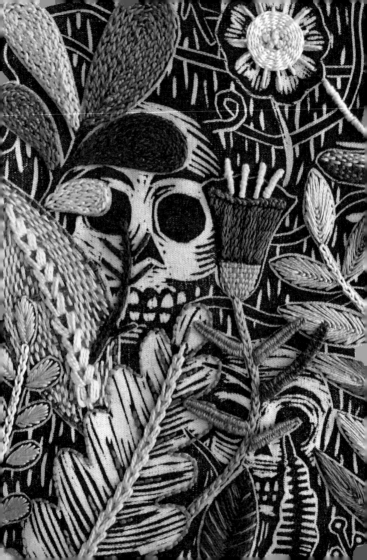

SOLEDAD
de ALFONSINA STORNI

PODRÍA TIRAR MI CORAZÓN DESDE AQUÍ
SOBRE UN TEJADO; MI CORAZÓN RODARÍA
SIN SER VISTO.

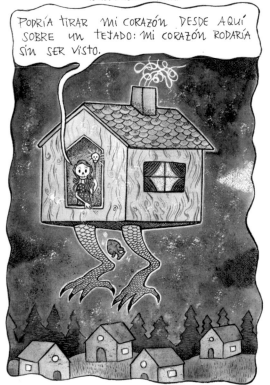

I could throw away my heart from here, on a roof:
my heart would roll
without being seen.

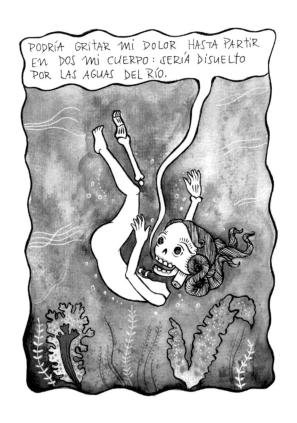

i could scream
my pain
until I split my body in two: it would be dissolved
by the waters of the river.

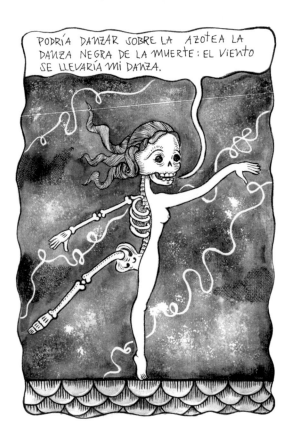

I could dance
on the roof
the black dance of death: the wind would take
my dance

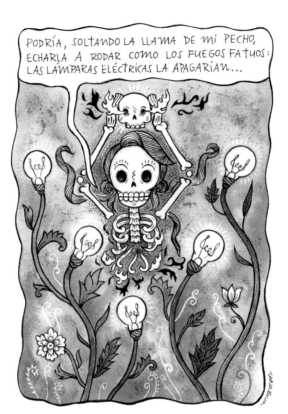

Might,
releasing the flame from my chest,
roll it like the fatuousfires: electric lamps
they would turn it off...

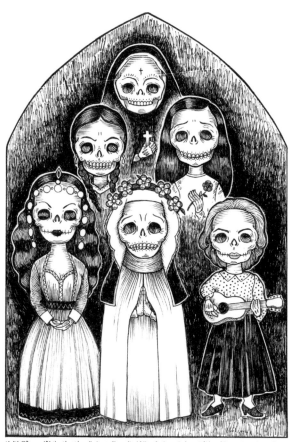

DE IZQUIERDA A DERECHA: YMA SUMAC, MICAELA BASTIDAS, MELCHORITA SARAVIA, SANTA ROSA DE LIMA, SARITA COLONIA Y CHABUCA GRANDA

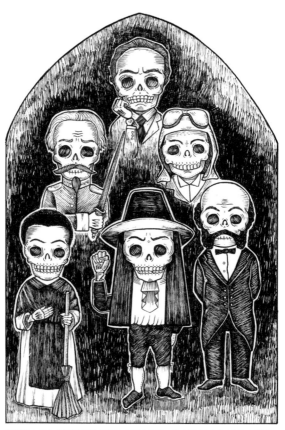

DE IZQUIERDA A DERECHA: SAN MARTÍN DE PORRES, FRANCISCO BOLOGNESI, CÉSAR VALLEJO, TUPAC AMARU, JOSE ABELARDO QUIÑONES Y MIGUEL GRAU

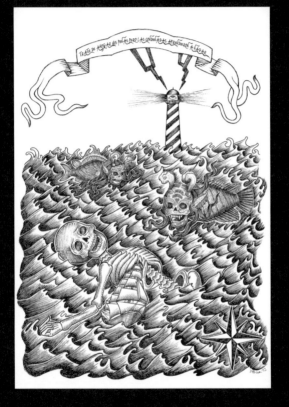

"I tried to sink my sorrows (with alcohol)
 but the fuckers learnt to swim."
 - Frida Kahlo

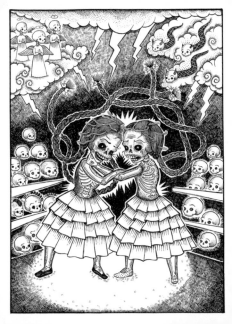

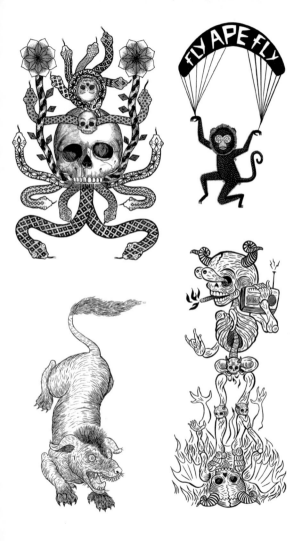

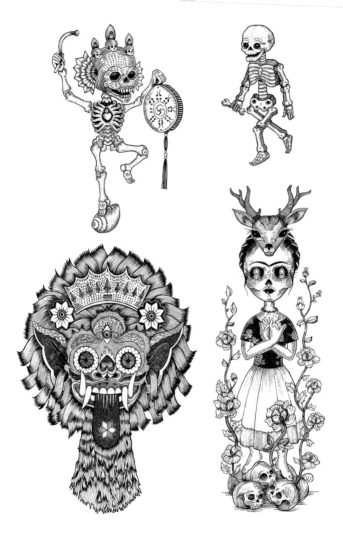

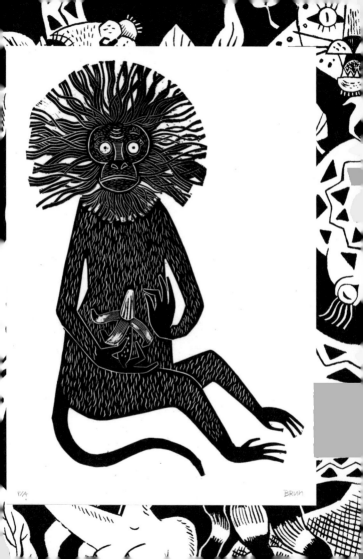

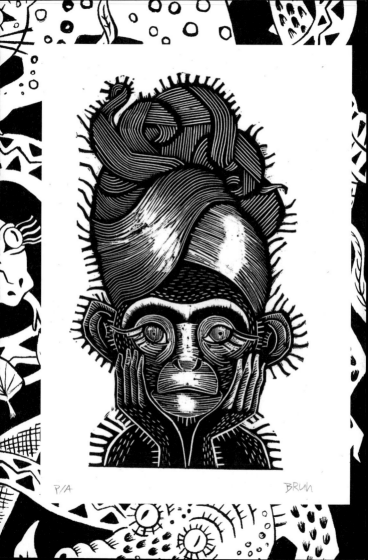

P/A BRUN

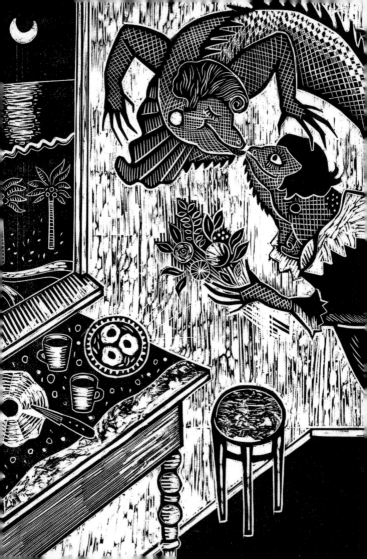

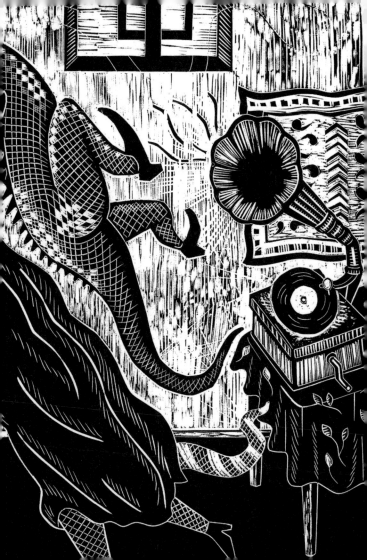

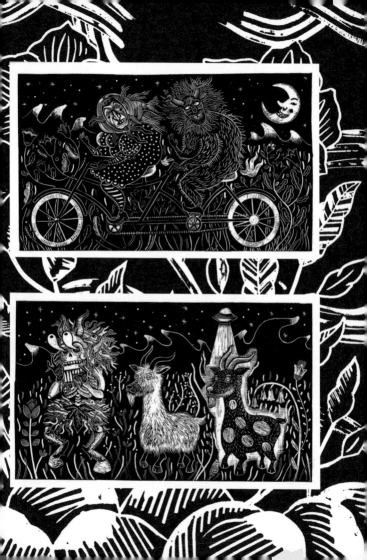

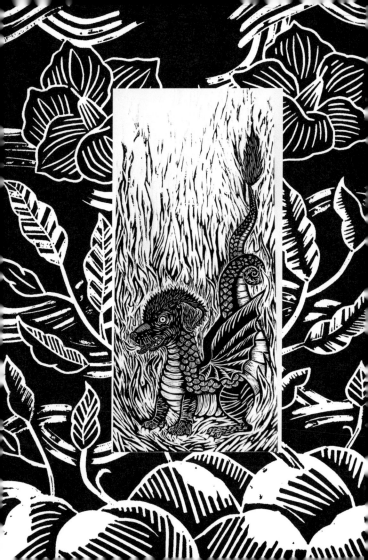

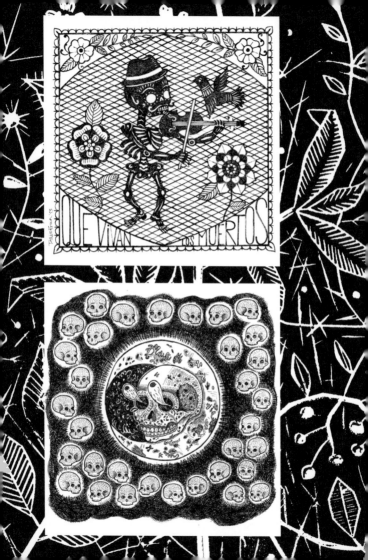

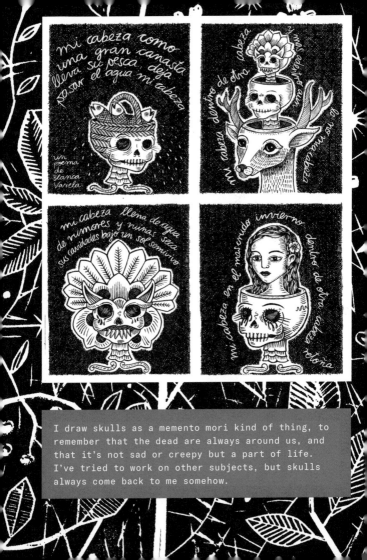

I draw skulls as a memento mori kind of thing, to remember that the dead are always around us, and that it's not sad or creepy but a part of life. I've tried to work on other subjects, but skulls always come back to me somehow.

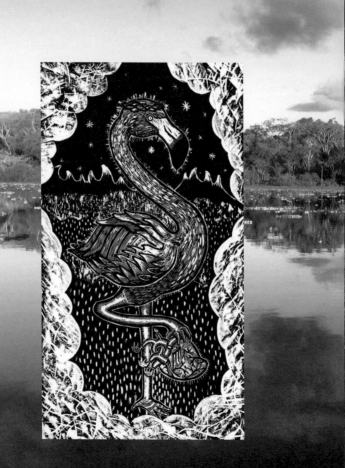

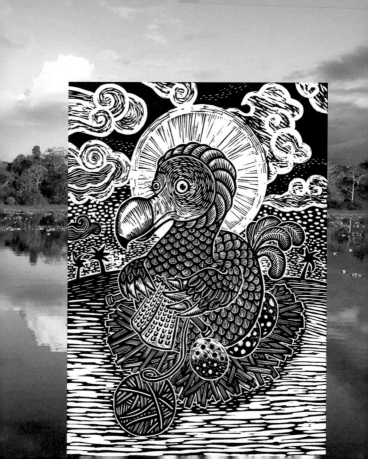

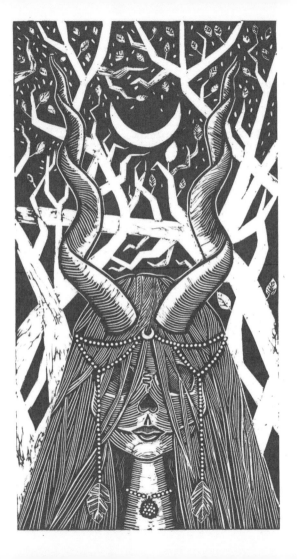

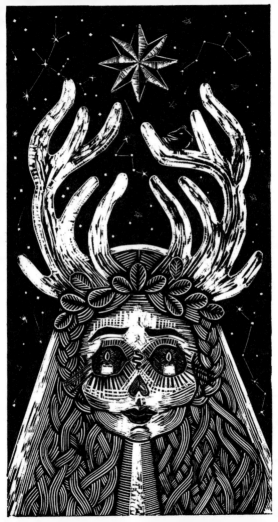

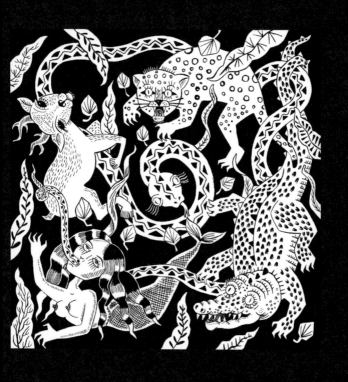

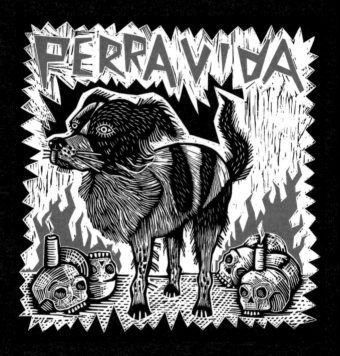

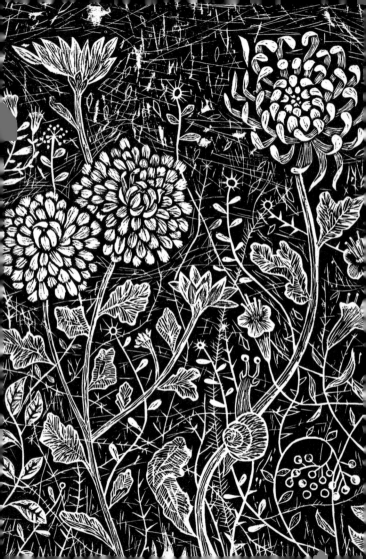

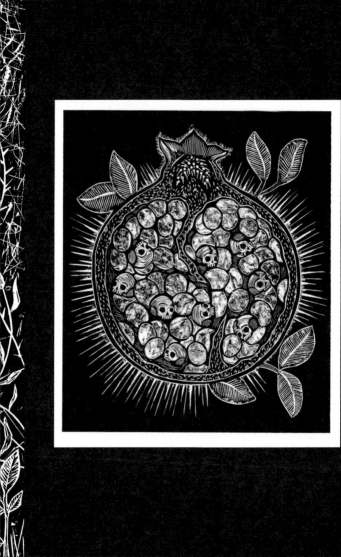

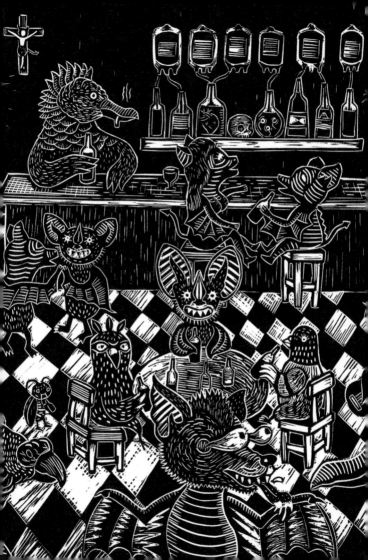

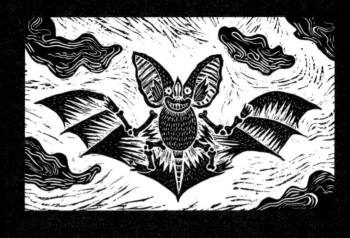

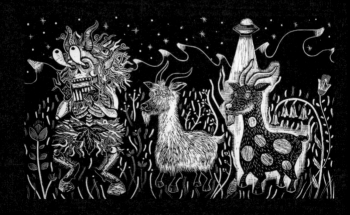

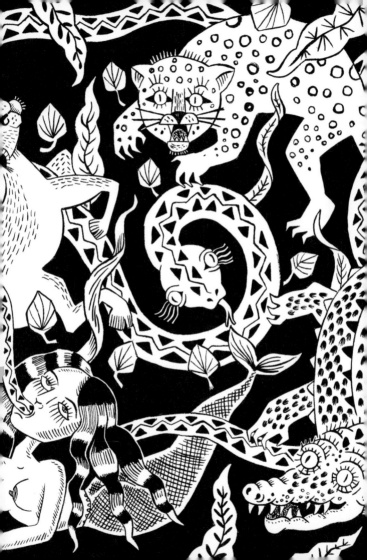

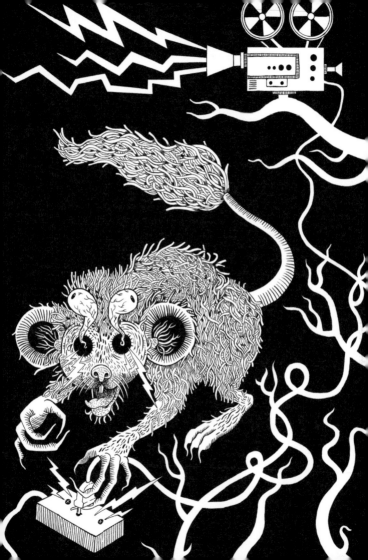

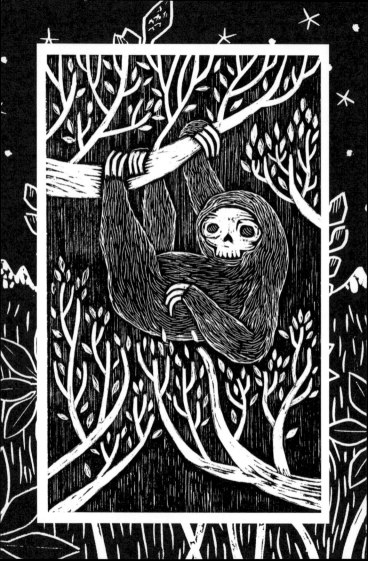

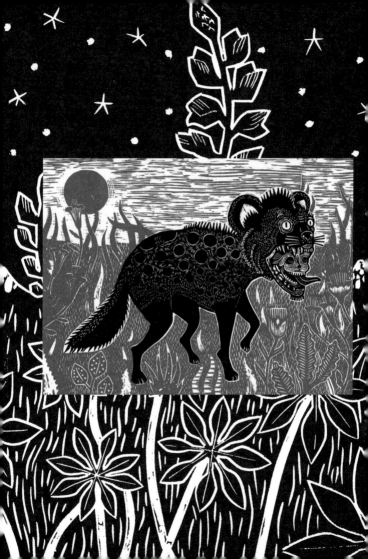

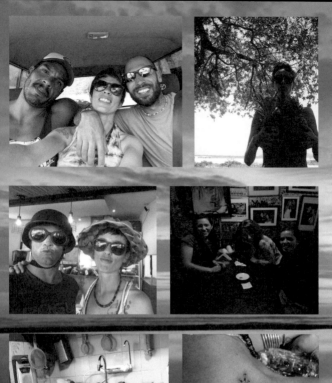

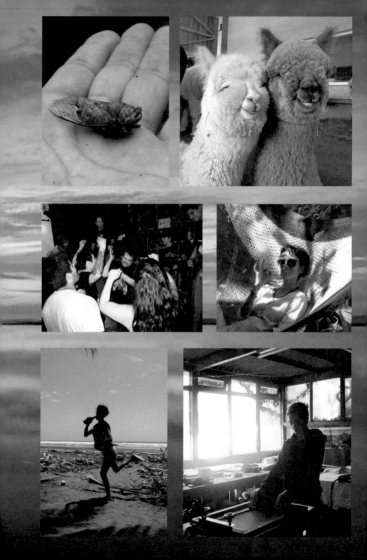

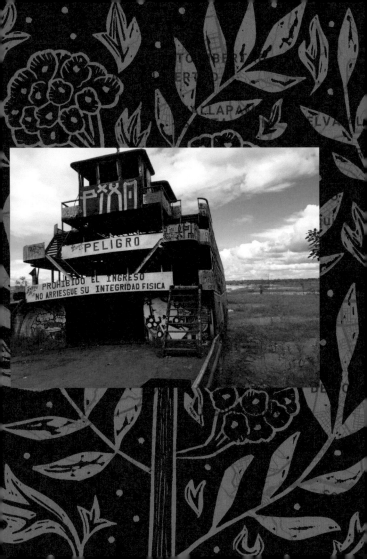

Miraflores

RE

ORES Urb. Mariano
 Bustamante

Mariano
Melgar

Paucarpata
District

s Luis
mante
trict

IN
YA

Sabandía
District

Characato
District